Meditations on Tea

A Coloring Book
to Soothe the Soul

With reflections from
Okakura Kakuzo's
The Book of Tea

TUTTLE Publishing

Tokyo | Rutland, Vermont | Singapore

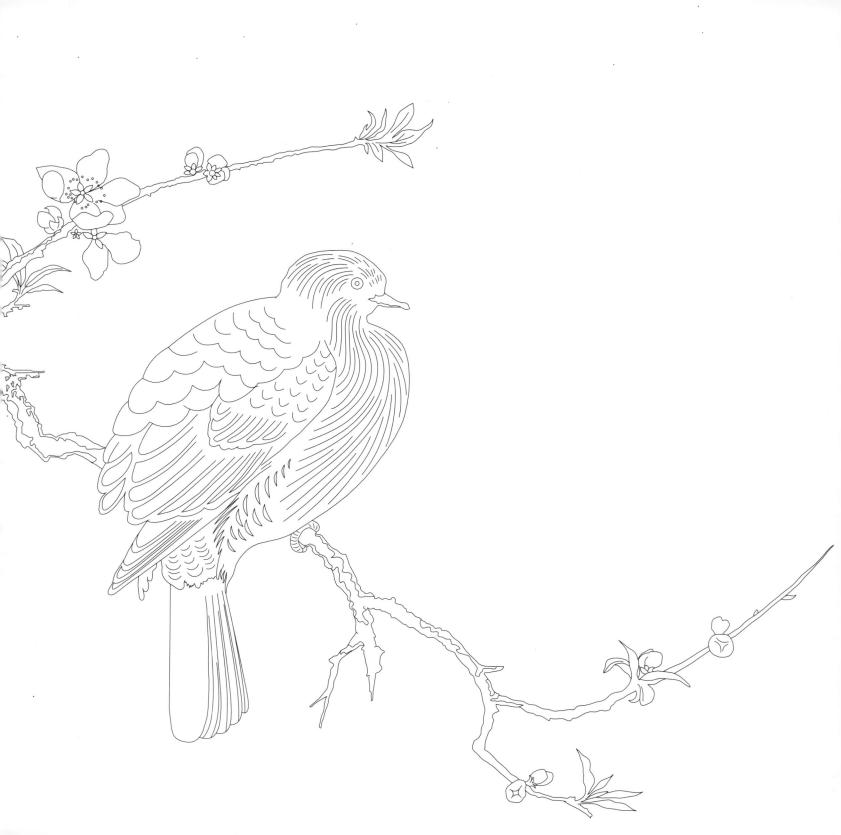

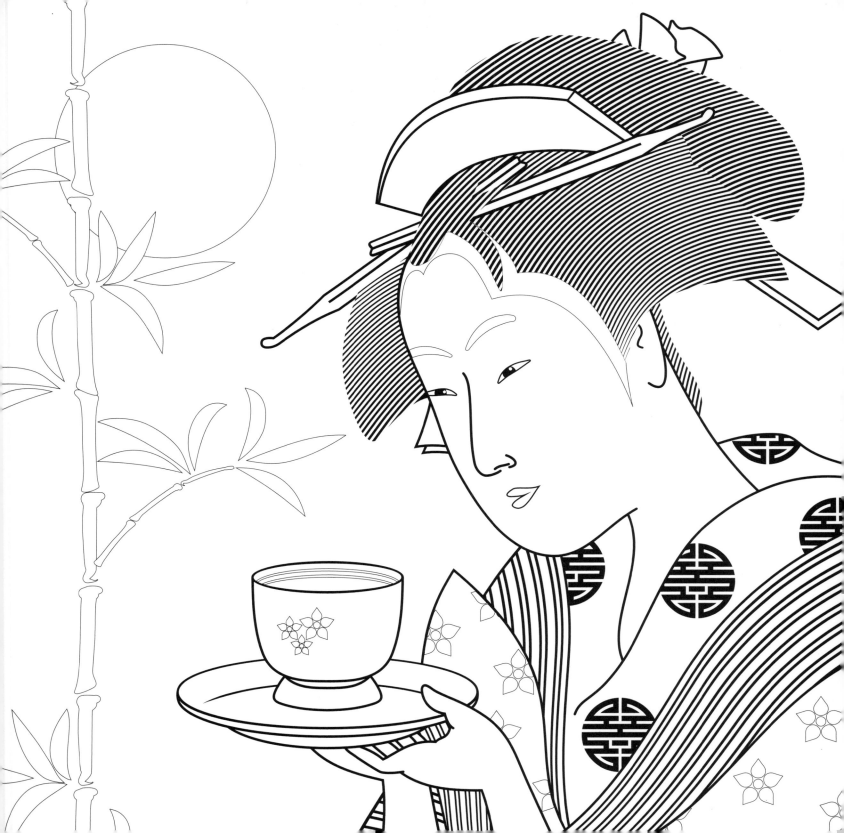

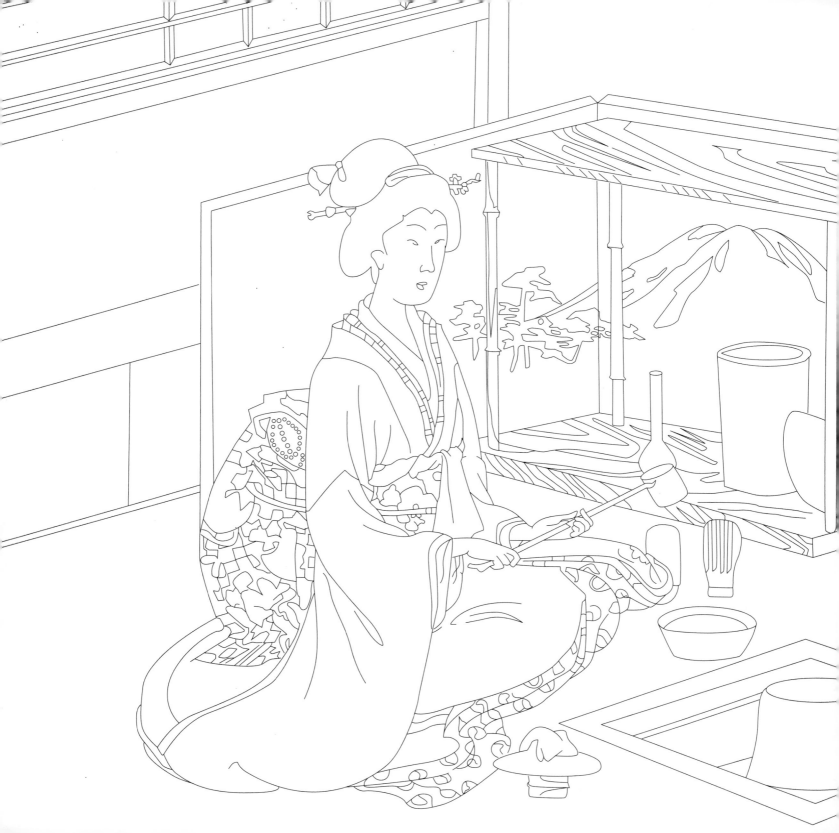

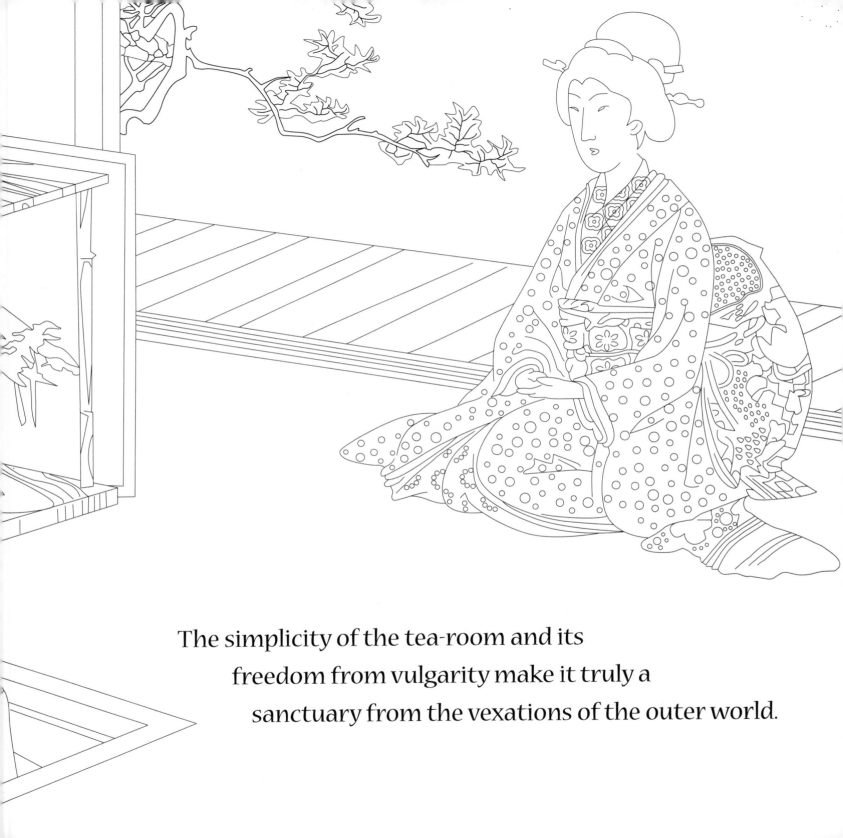

The simplicity of the tea-room and its
freedom from vulgarity make it truly a
sanctuary from the vexations of the outer world.

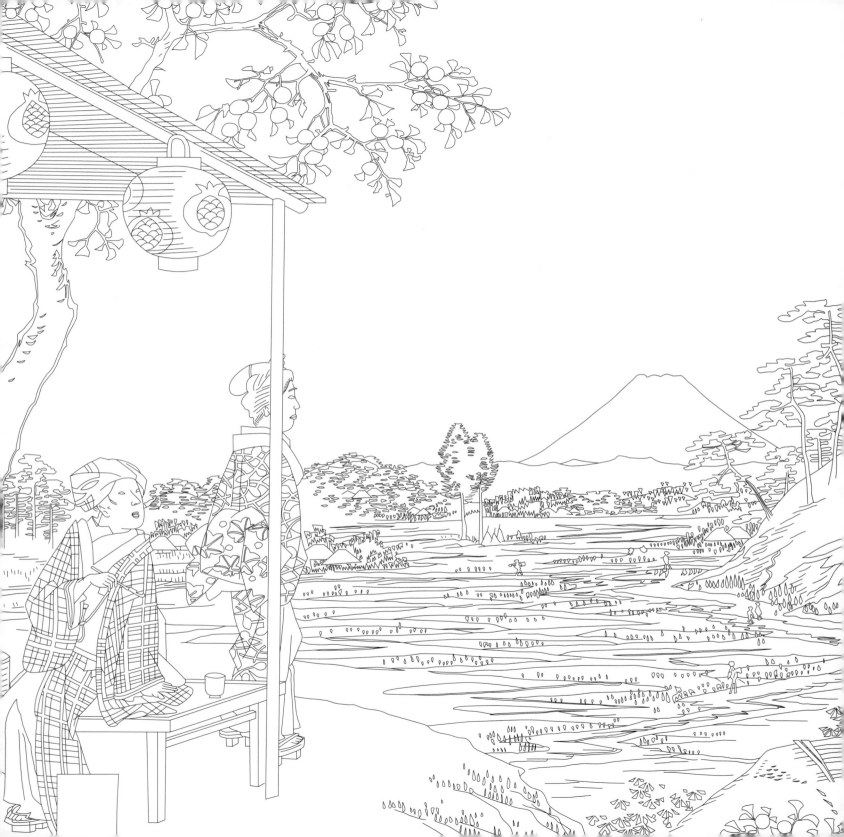

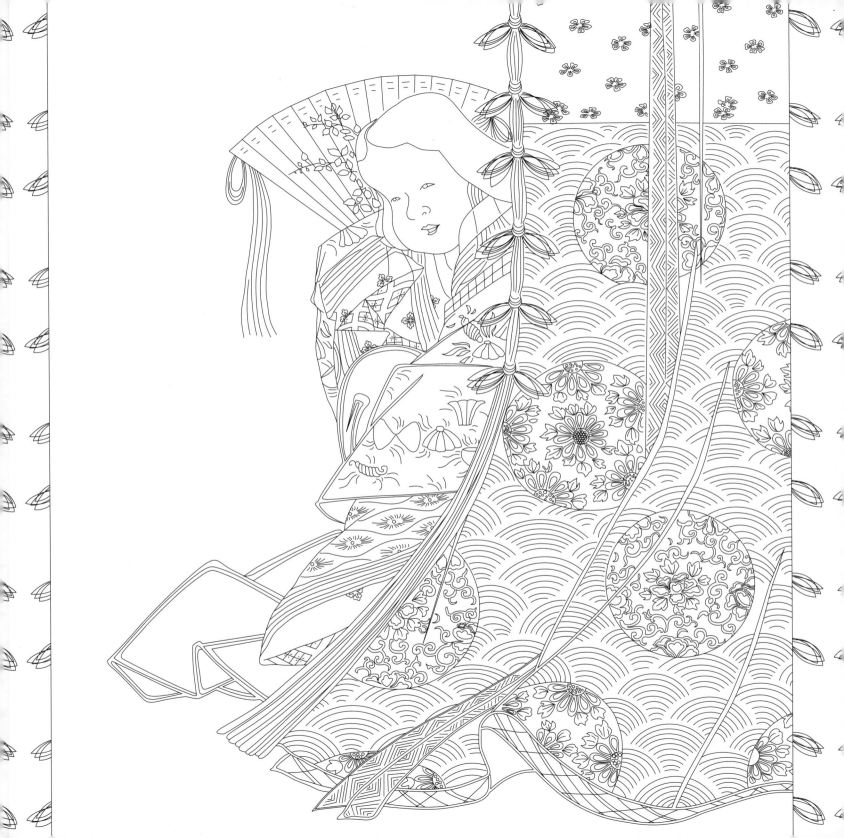

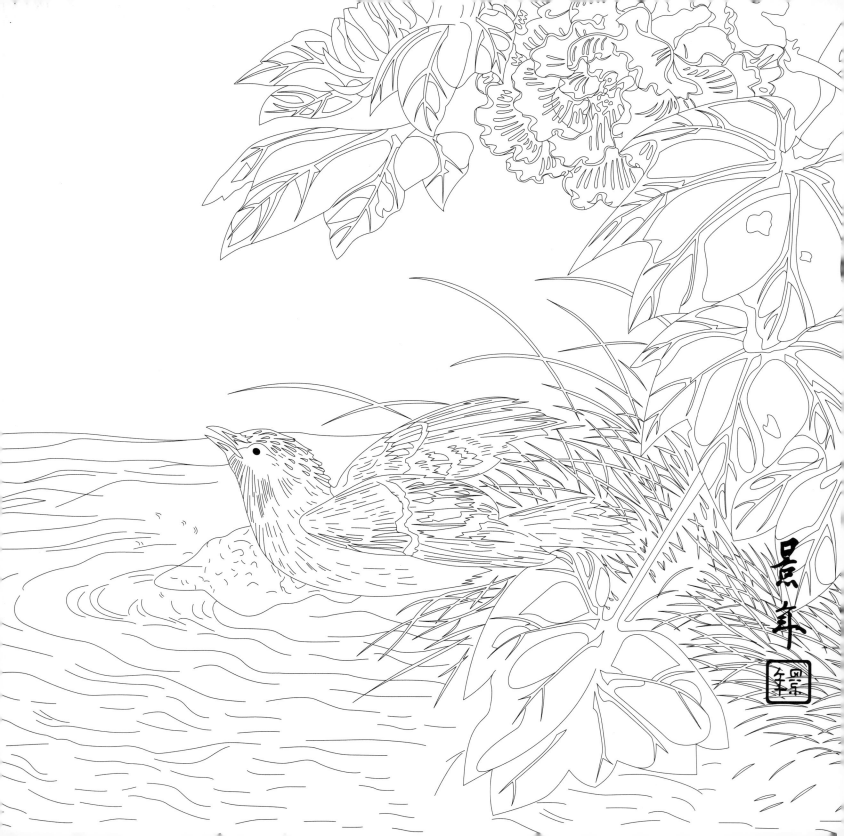

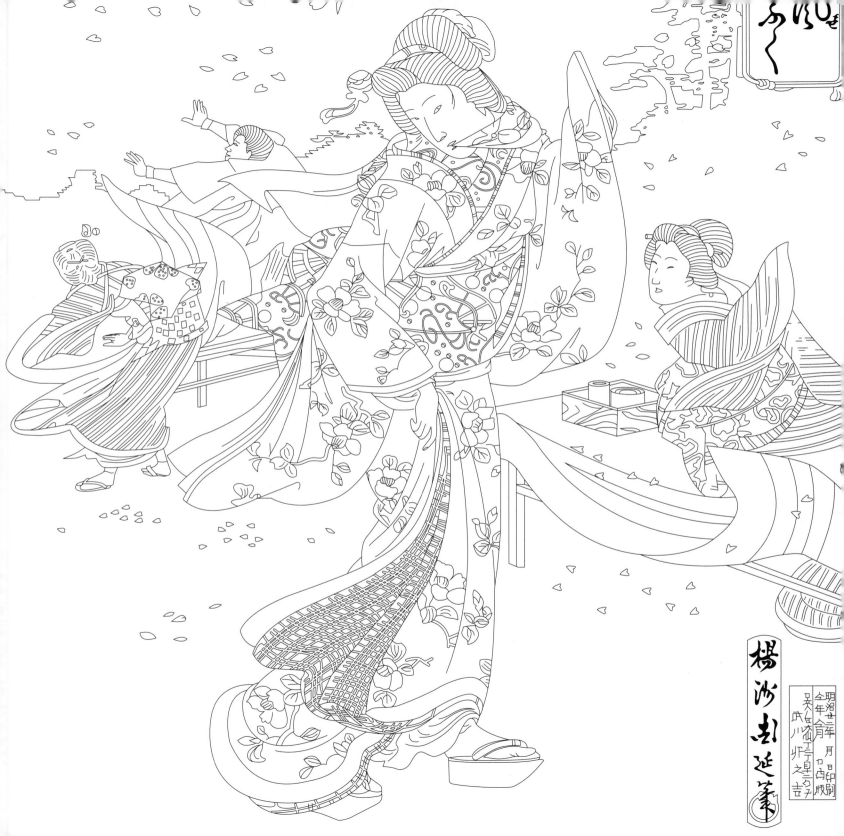

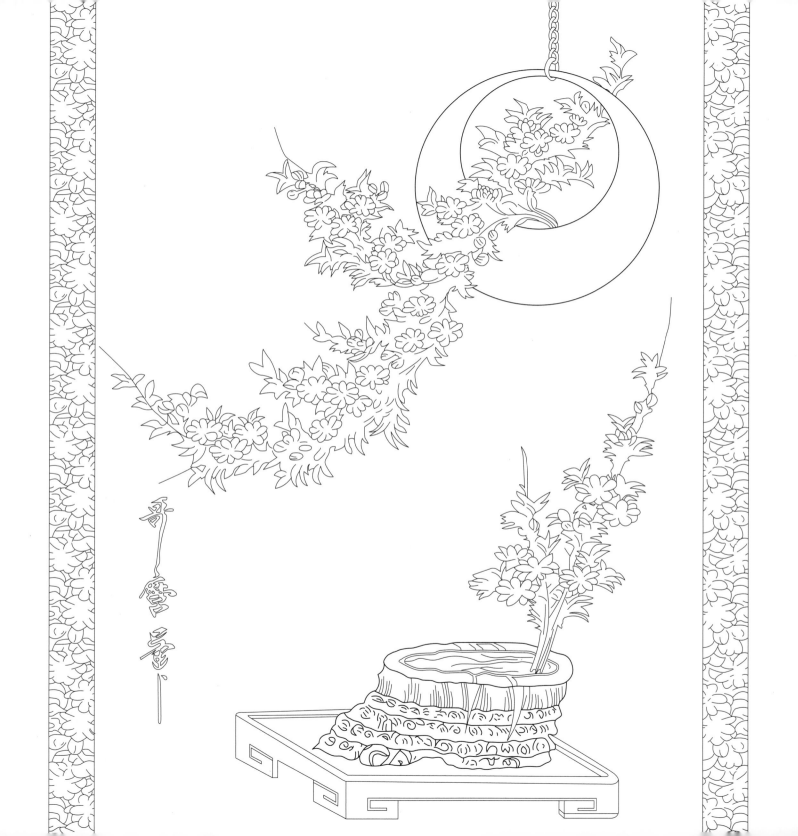

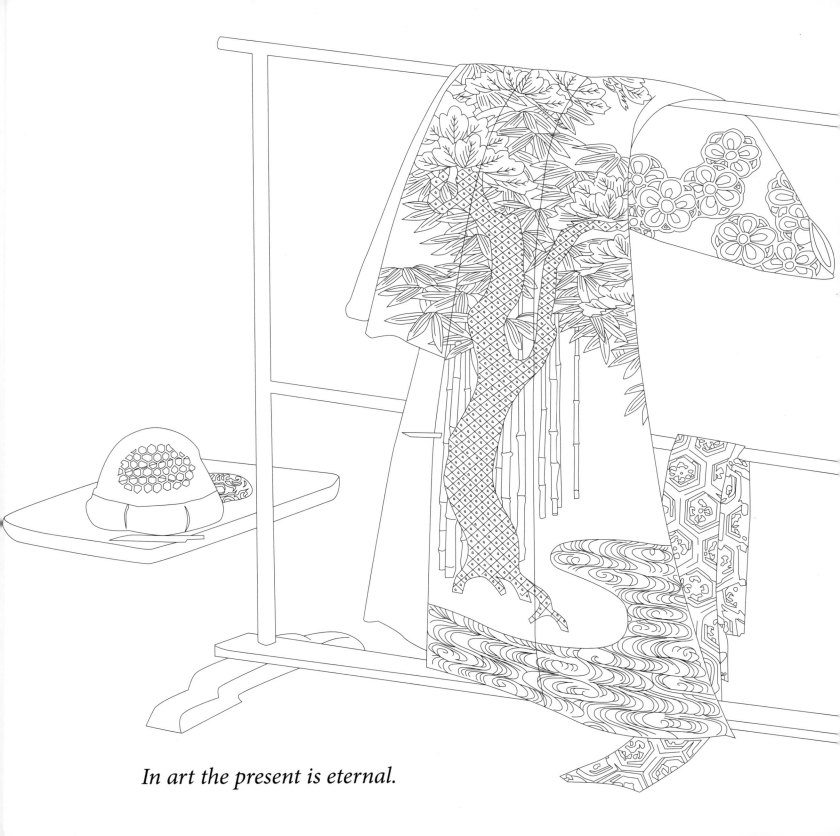

In art the present is eternal.

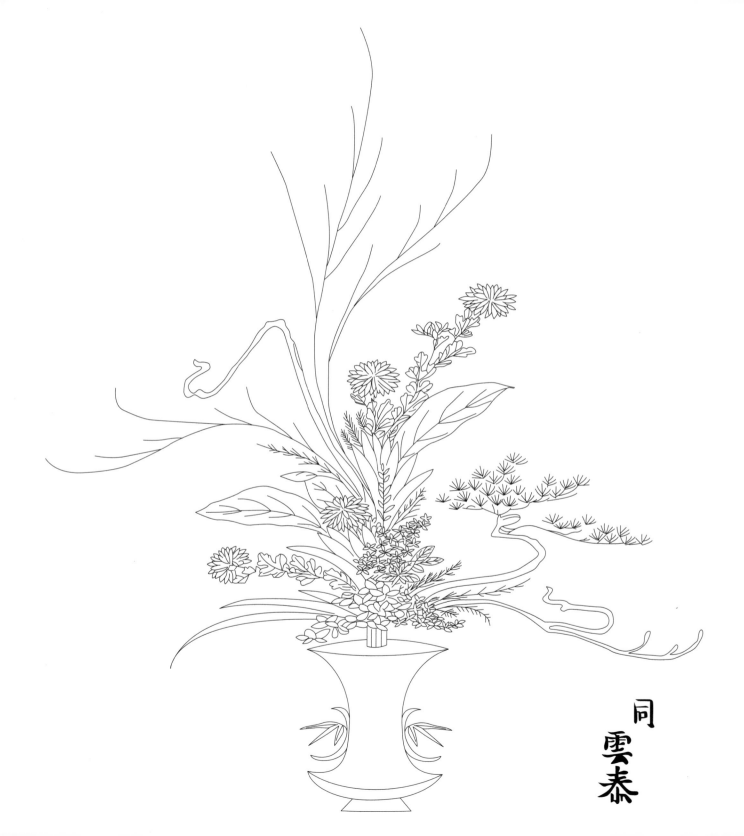

同
雲
泰

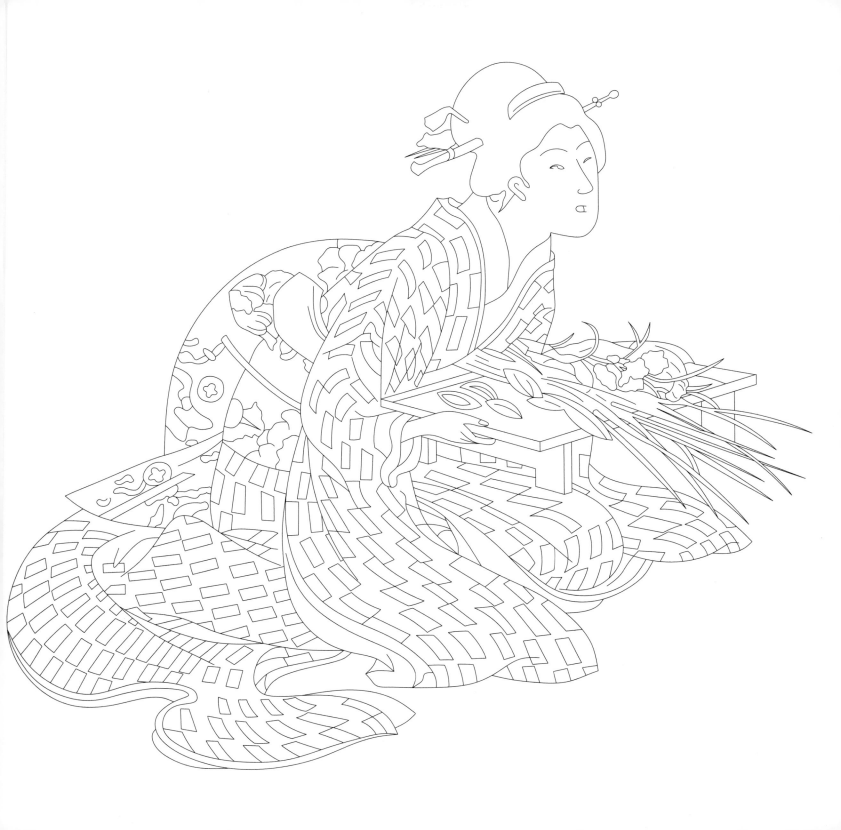

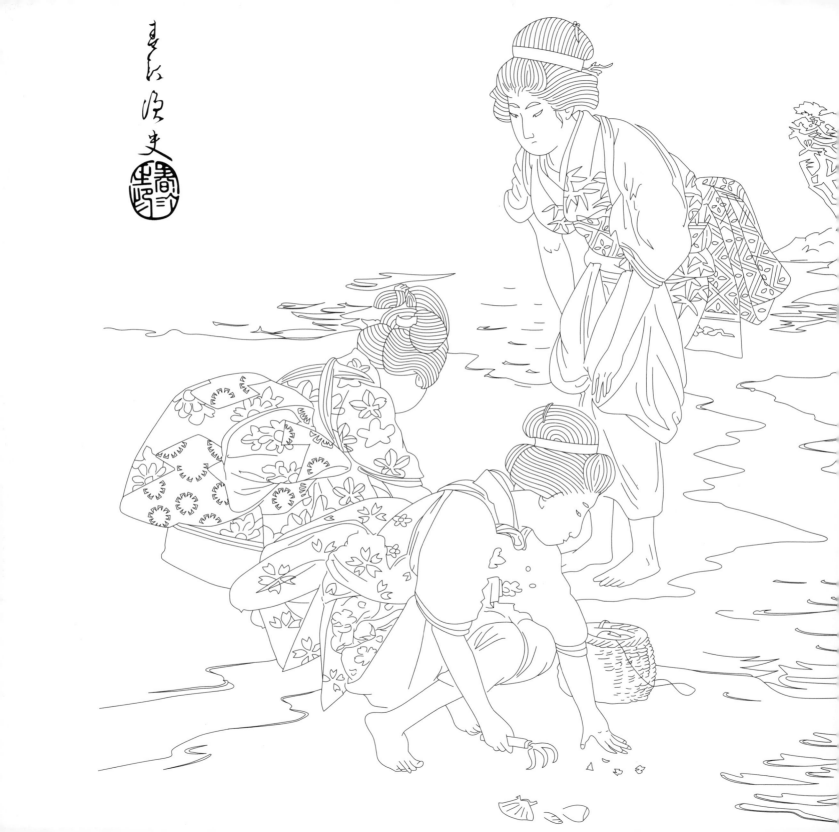

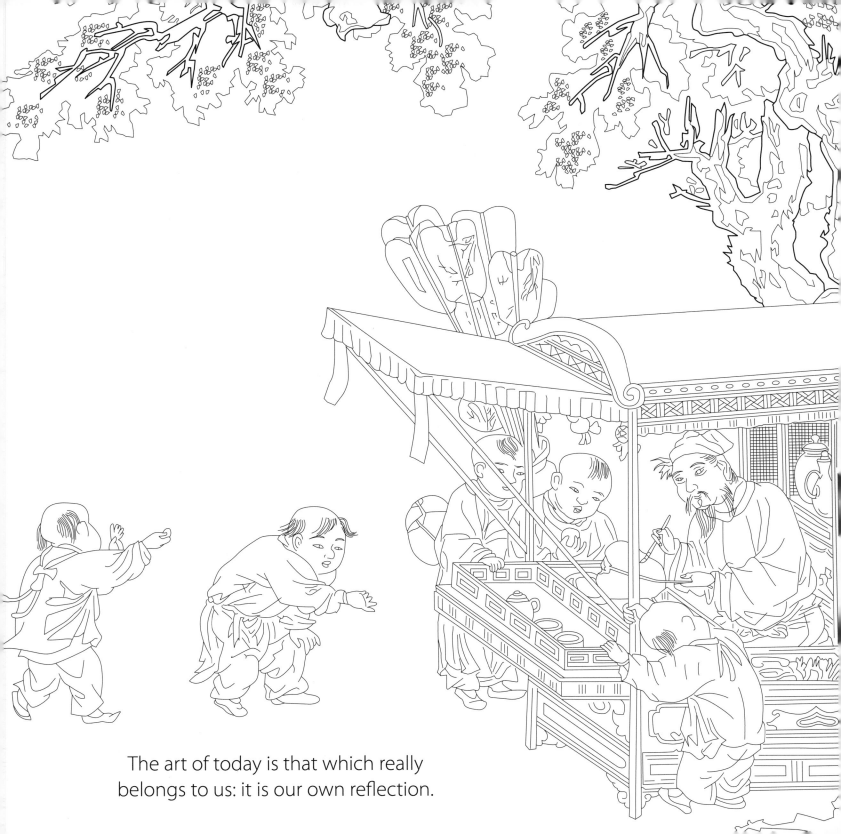

The art of today is that which really belongs to us: it is our own reflection.

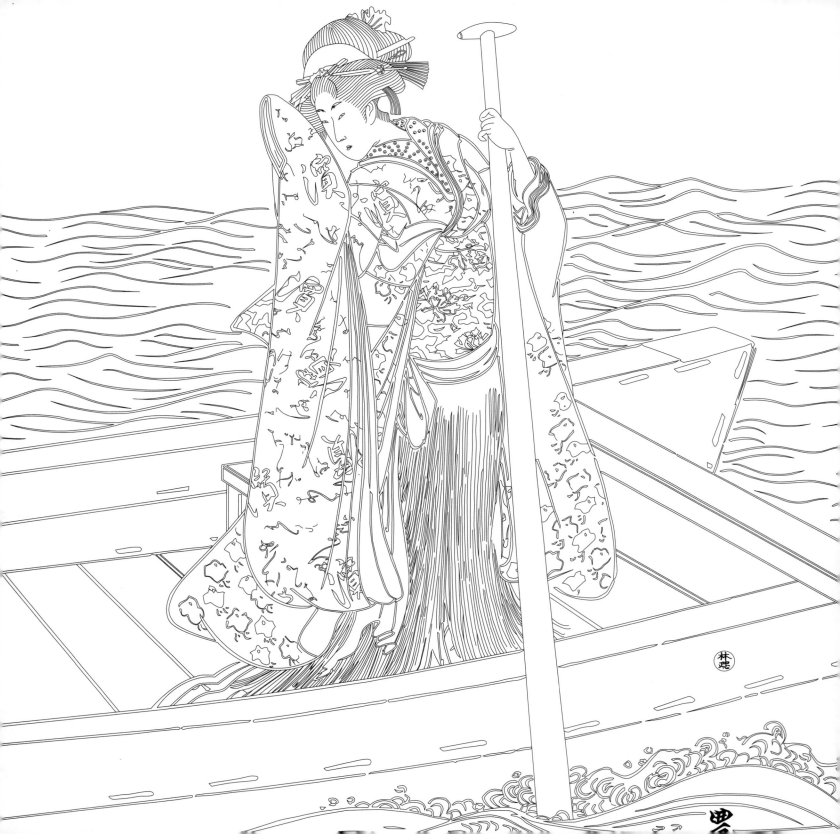

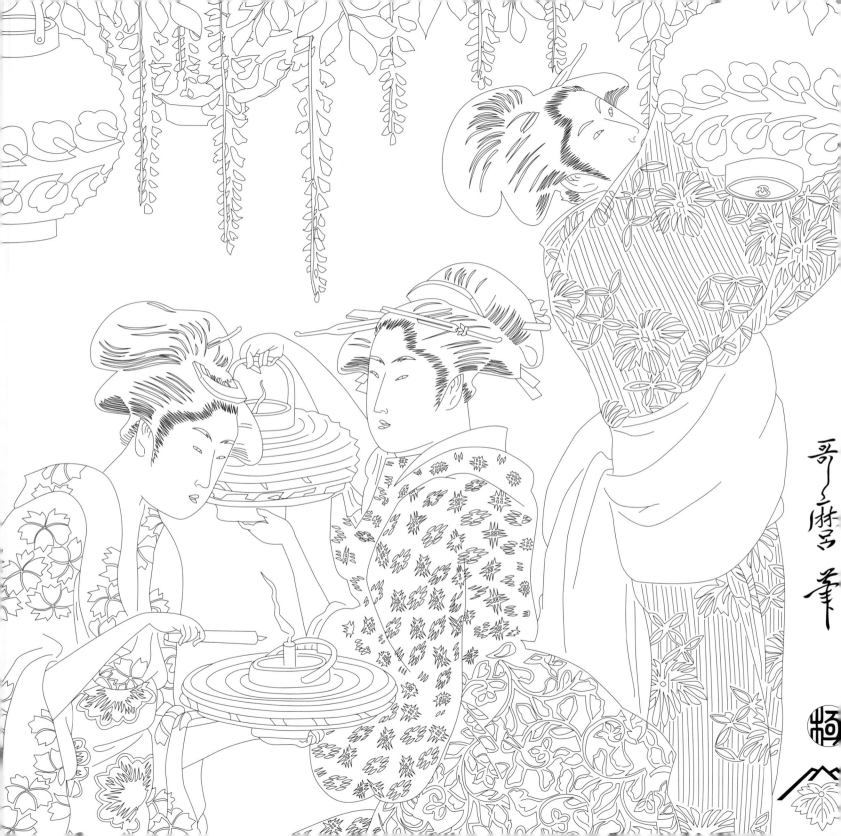

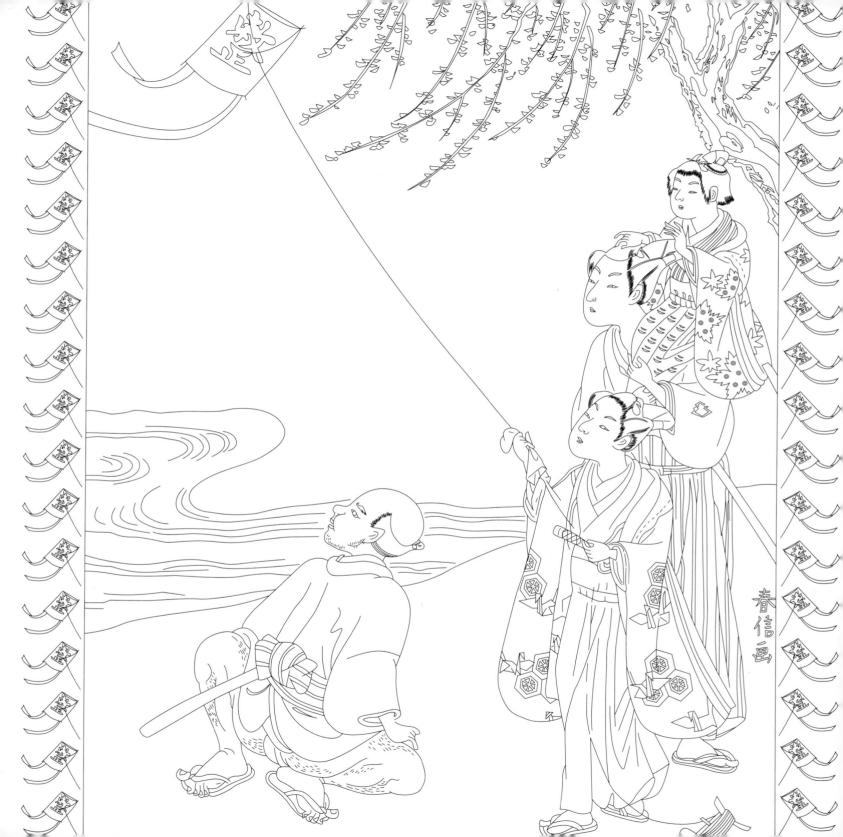

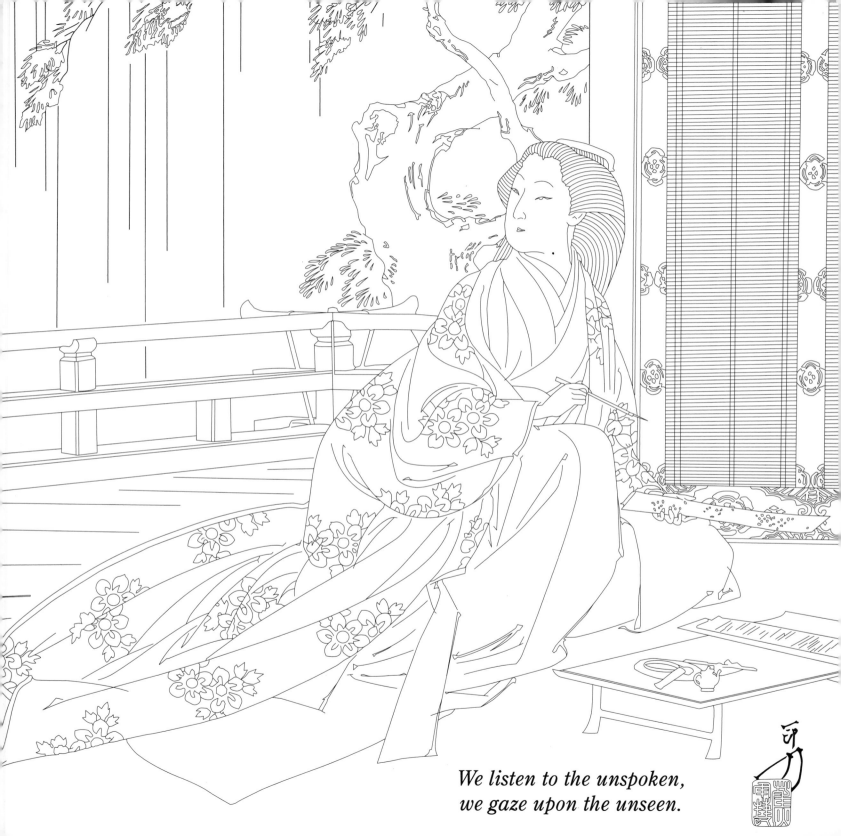

We listen to the unspoken,
we gaze upon the unseen.

At the magic touch of the beautiful the secret chords of our being are awakened...

...we vibrate and thrill in response to its call.

Teaism … is essentially a worship of the Imperfect… a tender attempt to accomplish something possible in this impossible thing we know as life.

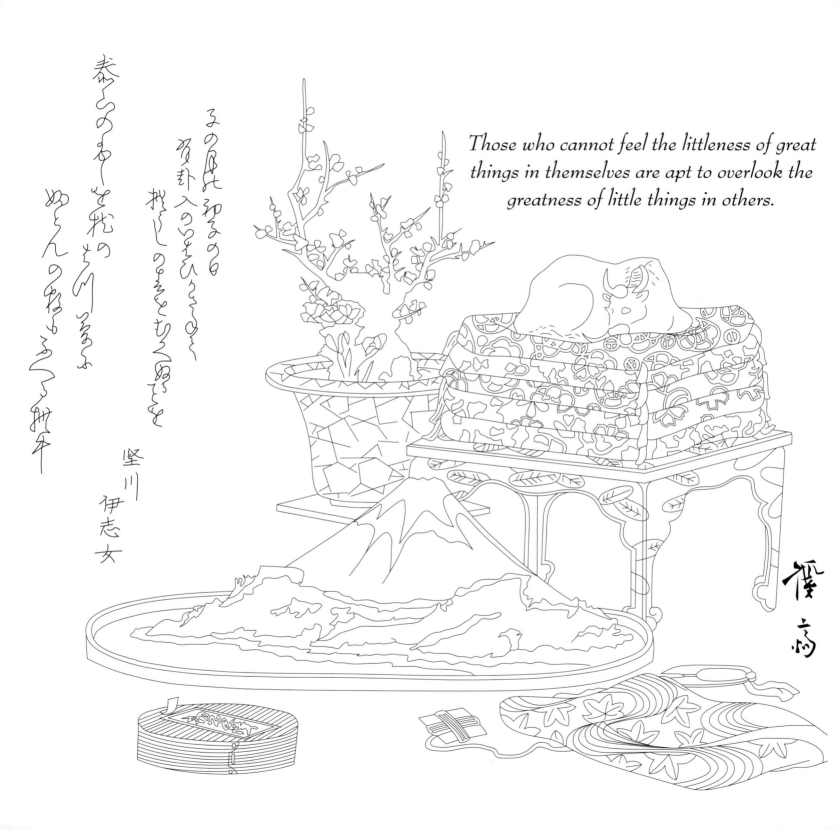

Those who cannot feel the littleness of great things in themselves are apt to overlook the greatness of little things in others.

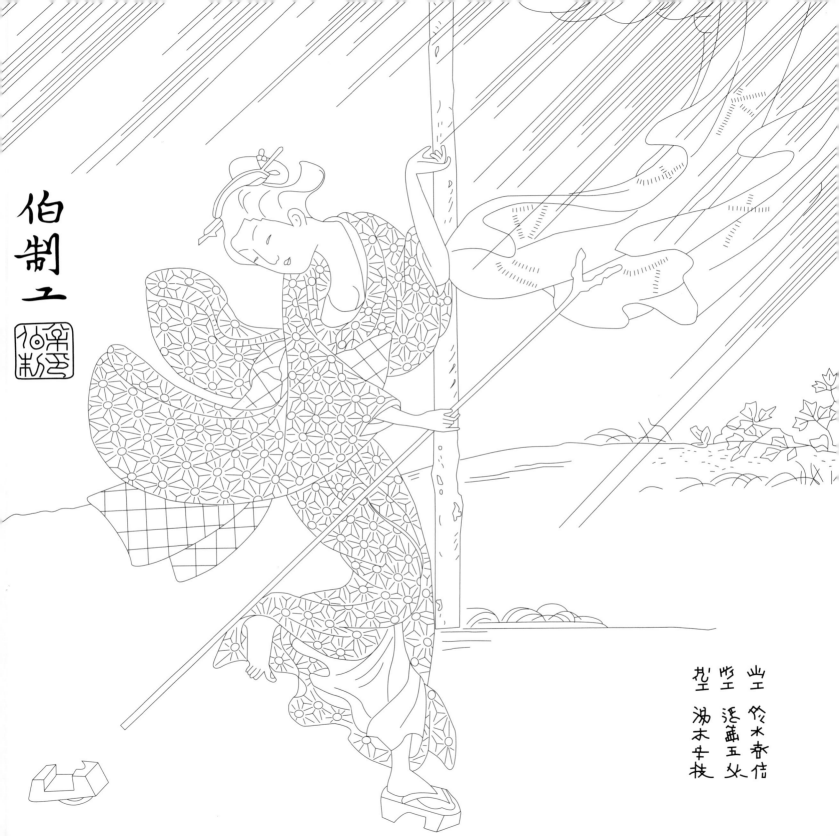

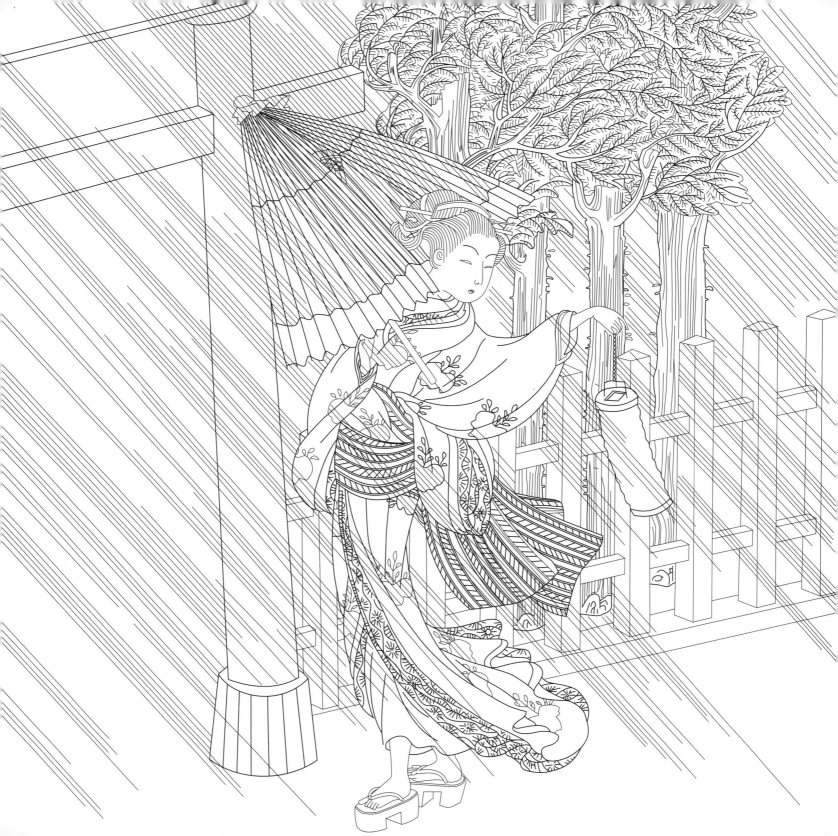

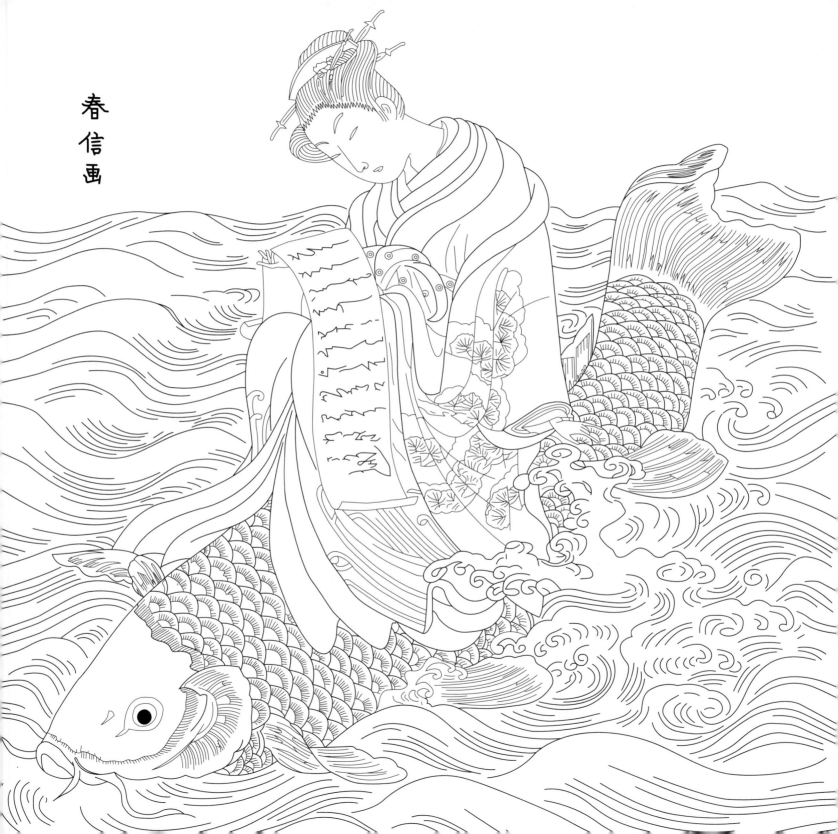

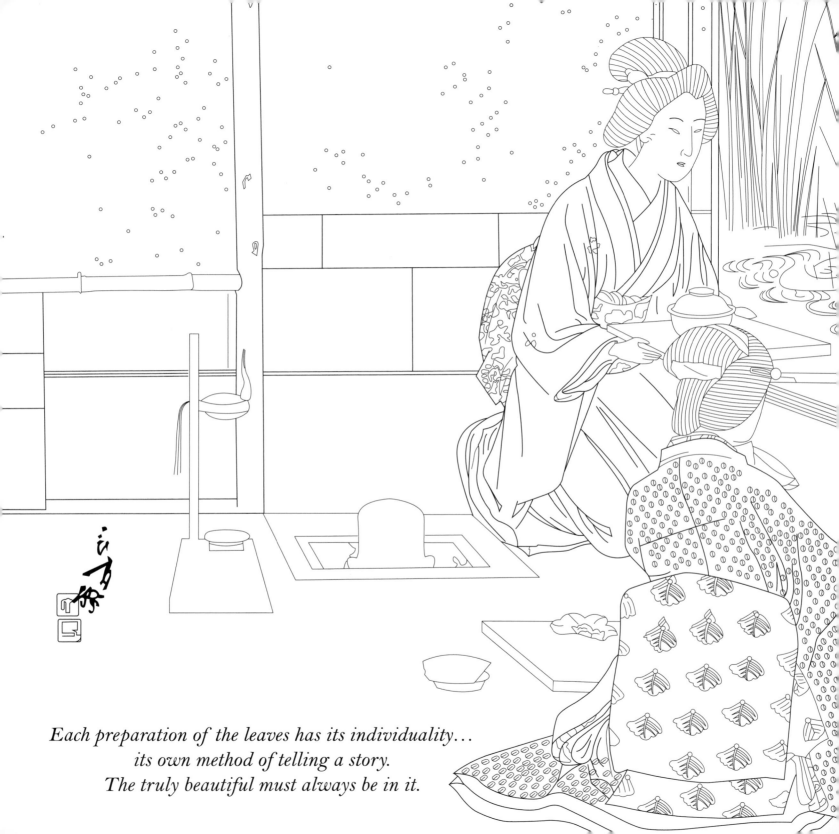

Each preparation of the leaves has its individuality…
its own method of telling a story.
The truly beautiful must always be in it.

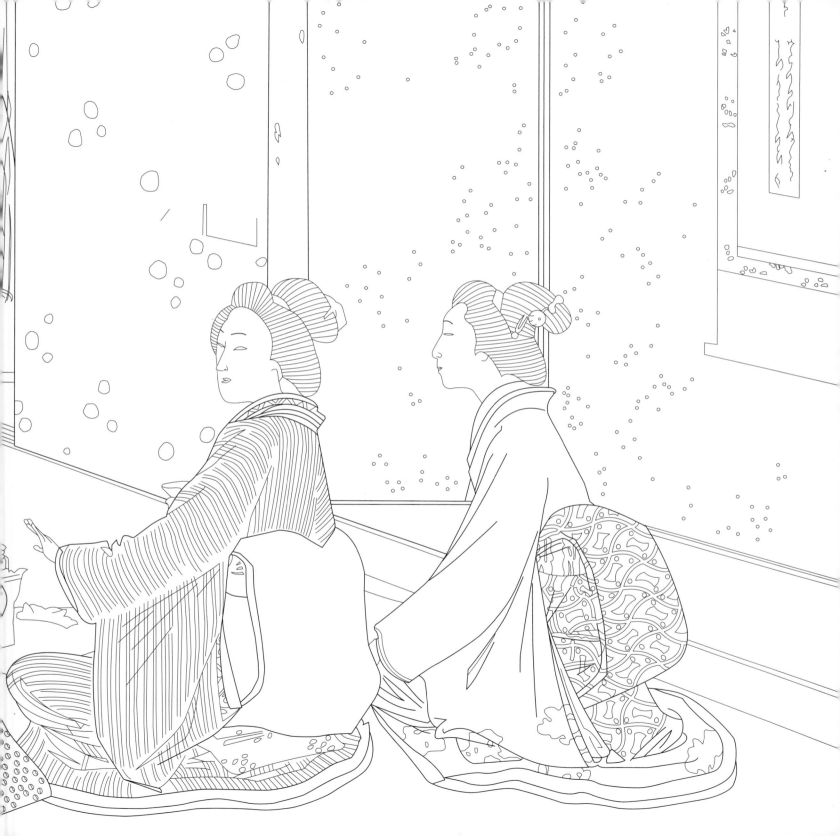

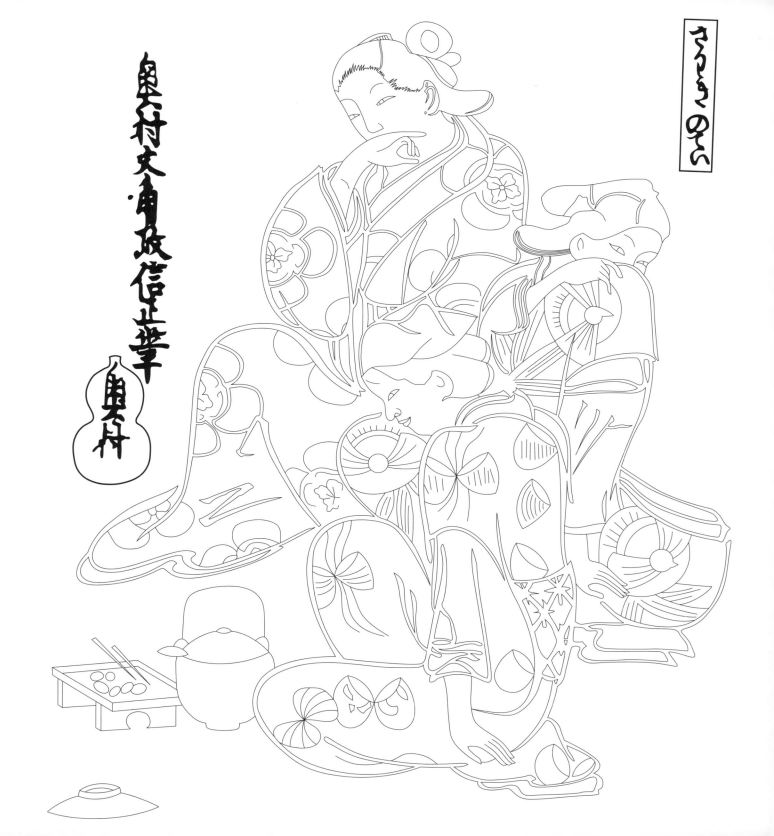

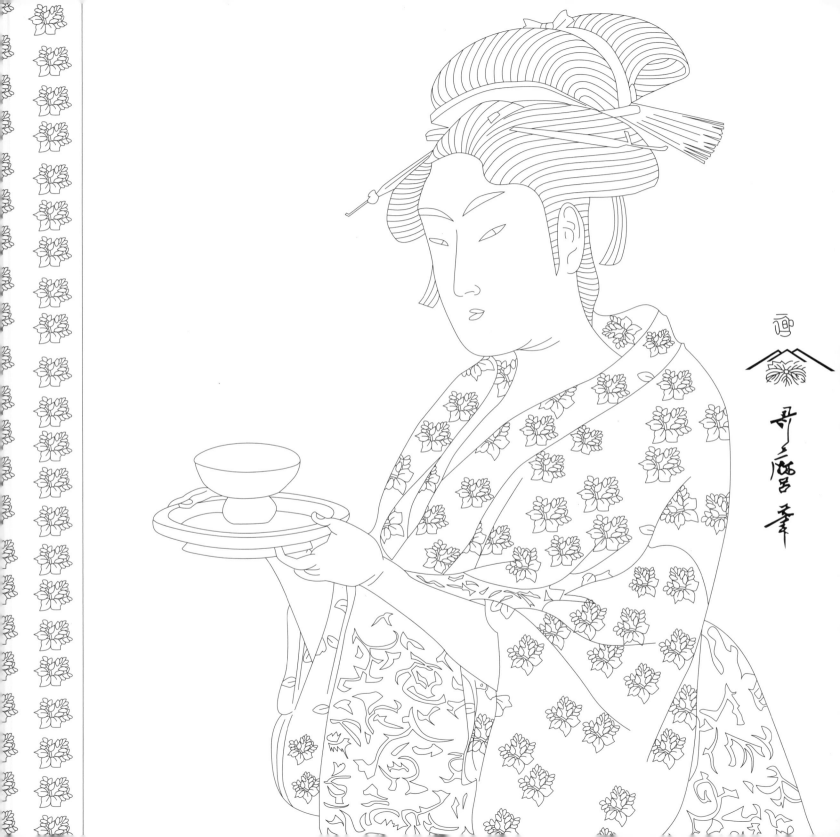

The ideal lover of flowers is
he who visits them
in their natural haunts.

Memories long forgotten all come back to us with a new significance.

Hopes stifled by fear, yearnings that we dare not recognize, stand forth in new glory.

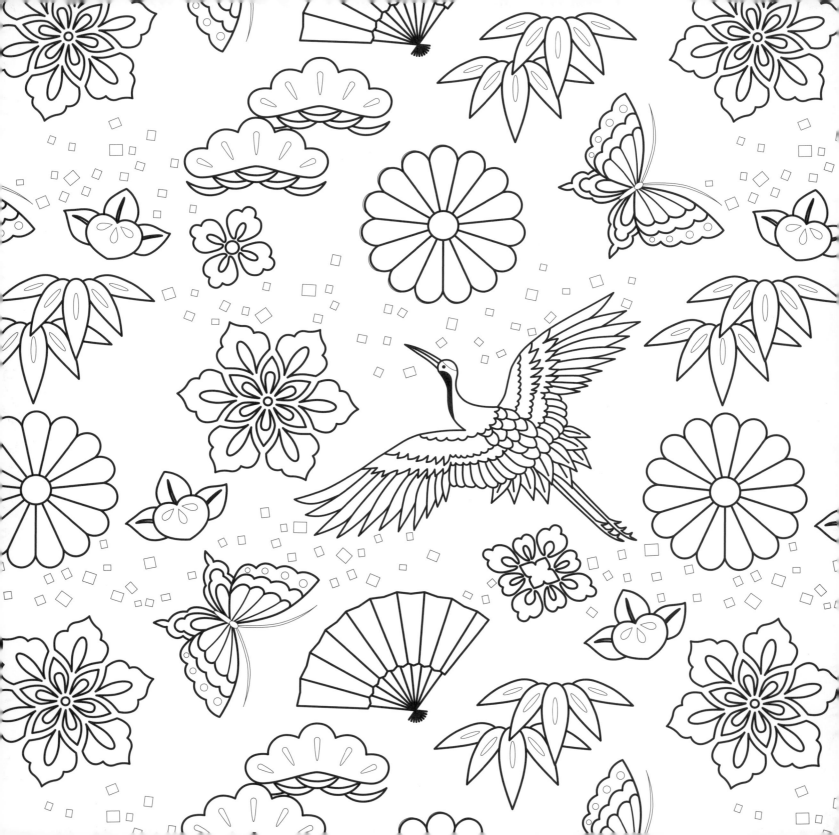

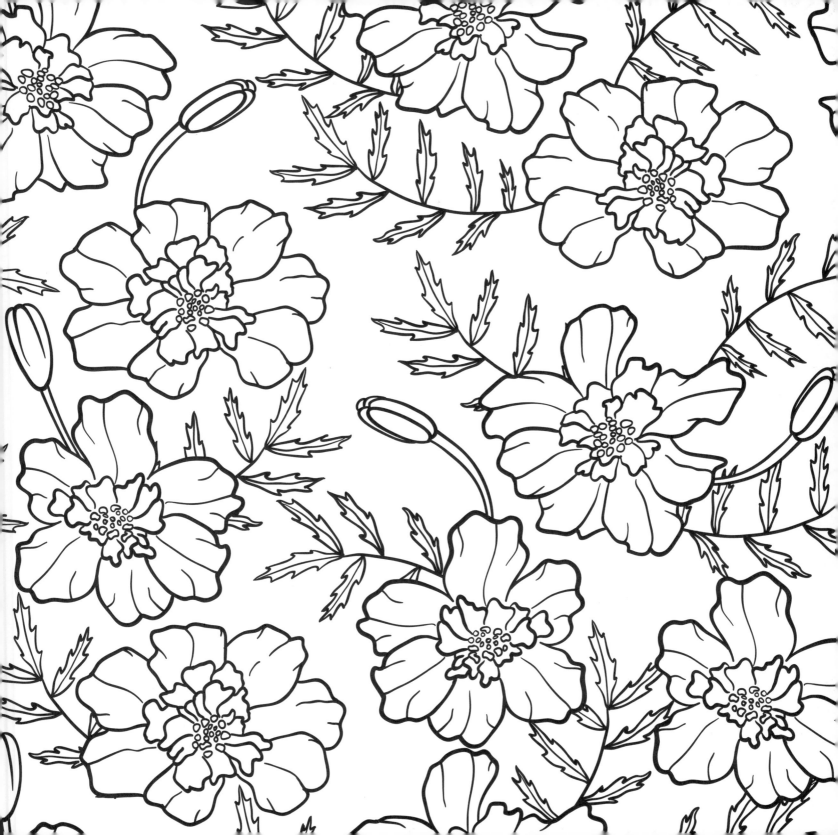

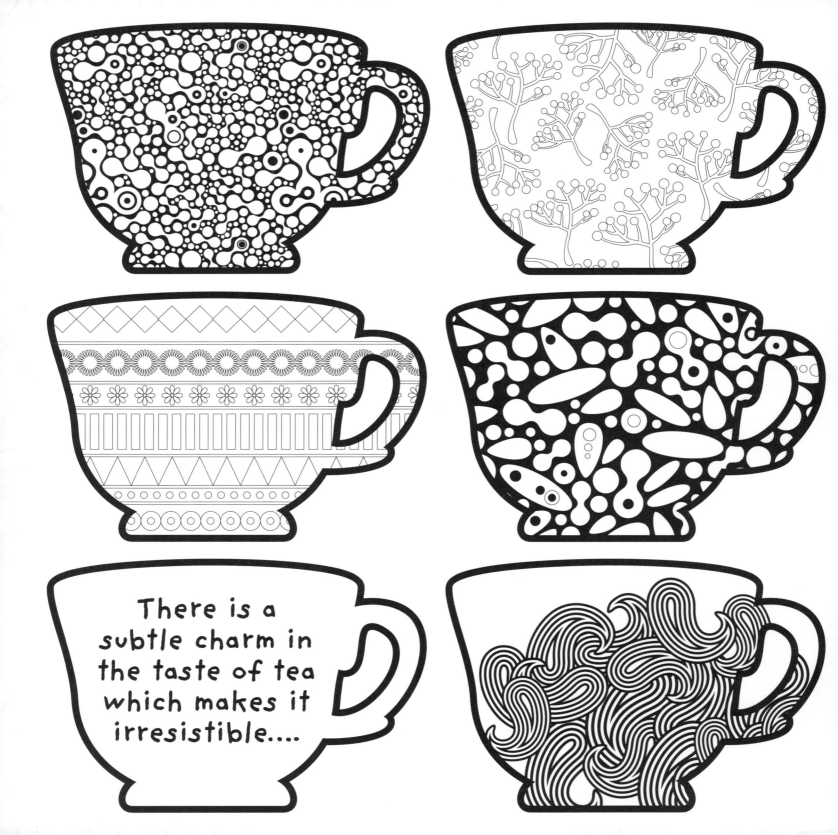

There is a subtle charm in the taste of tea which makes it irresistible....

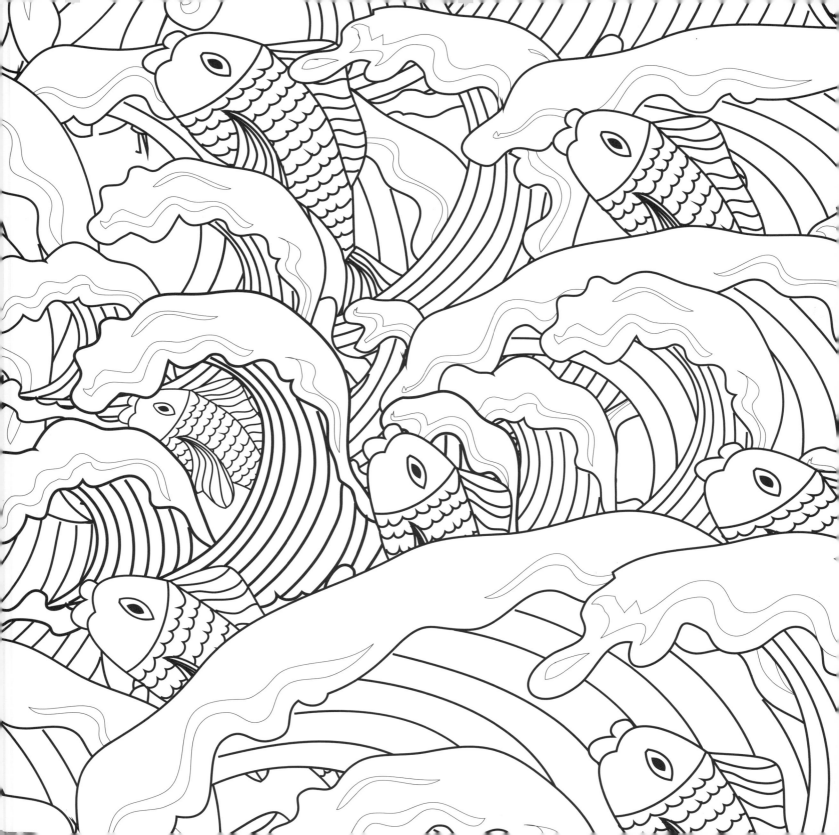

Tea...is a religion
of the art of life.

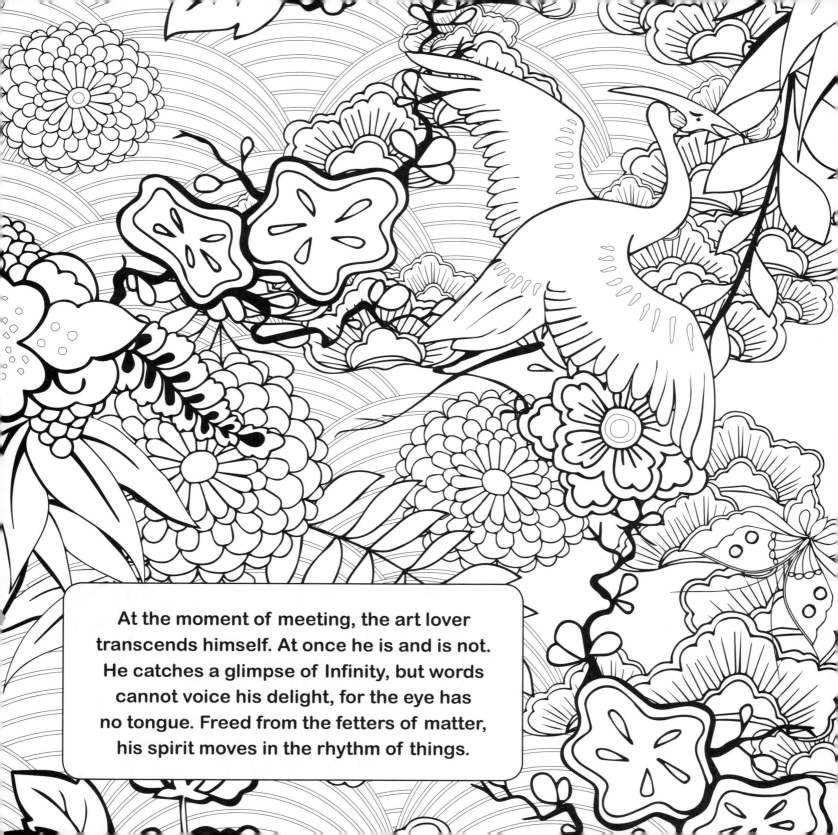

At the moment of meeting, the art lover transcends himself. At once he is and is not. He catches a glimpse of Infinity, but words cannot voice his delight, for the eye has no tongue. Freed from the fetters of matter, his spirit moves in the rhythm of things.

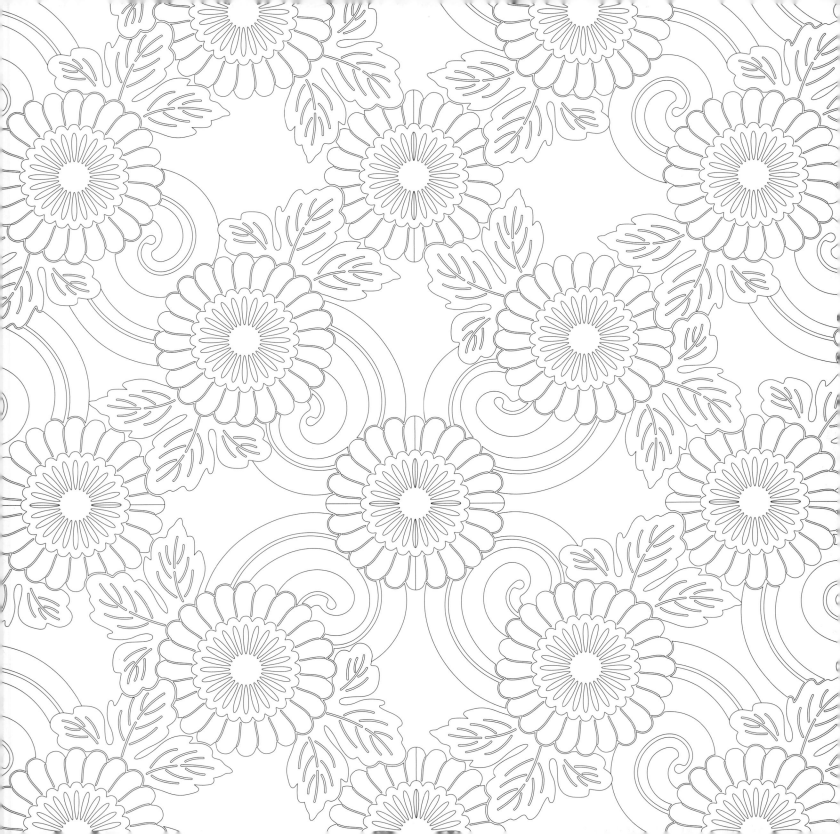

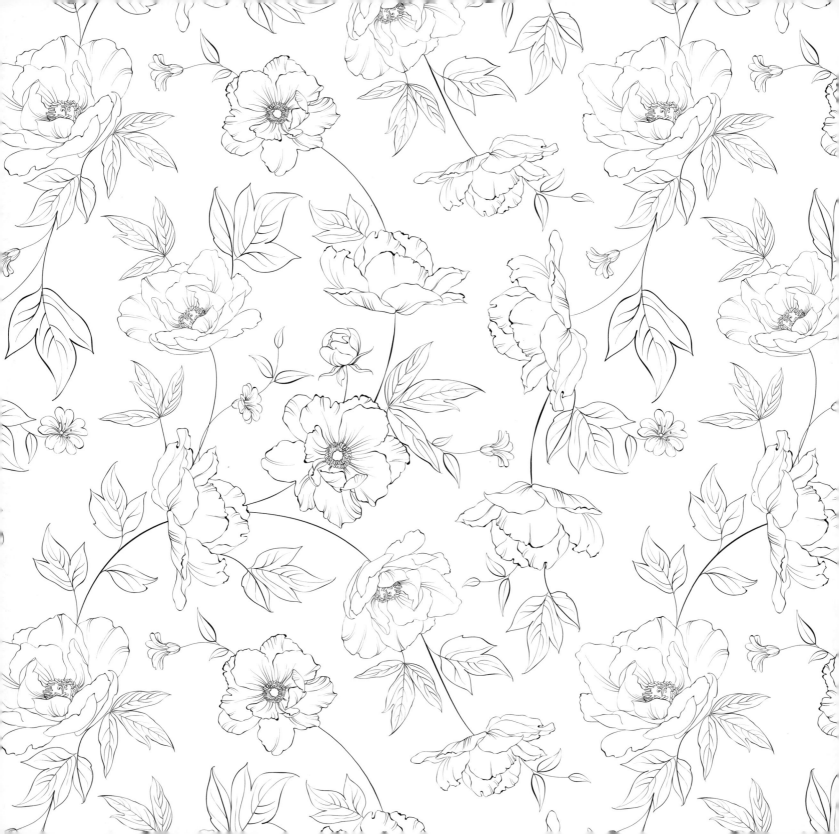

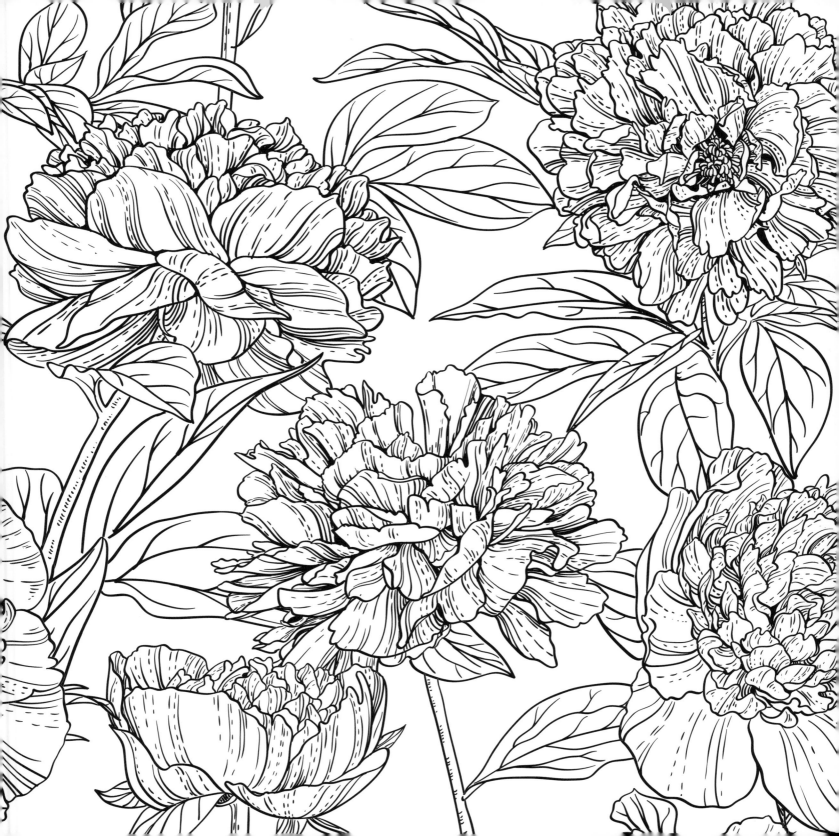

Let us dream of evanescence, and linger in the beautiful foolishness of things.

We have worshipped with the lily, we have meditated with the lotus....

We have even attempted to speak in the language of flowers.

How could we live without them?

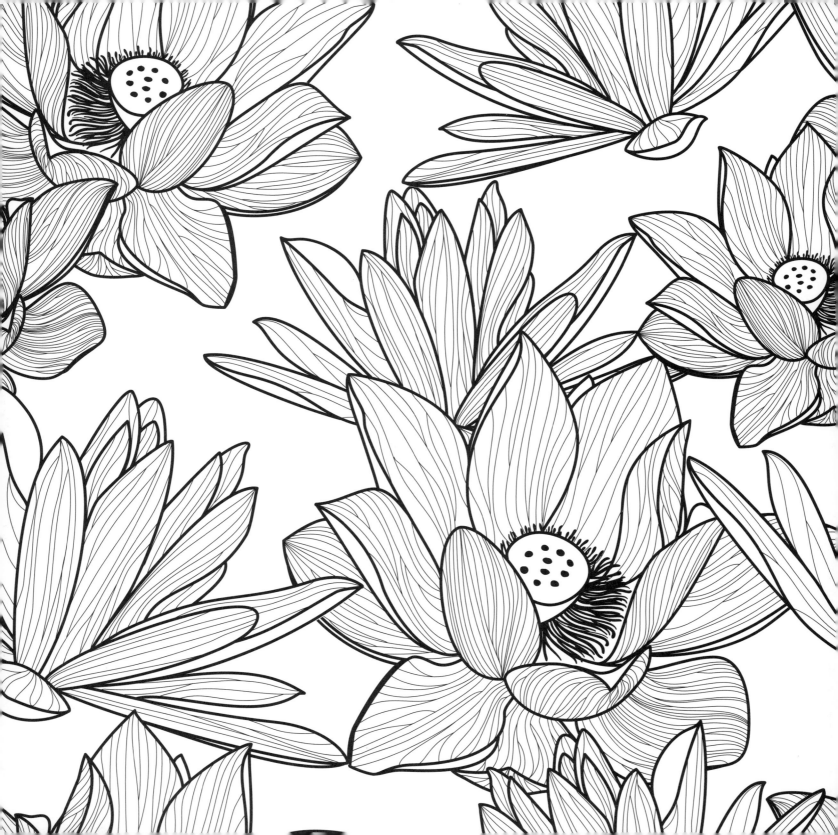

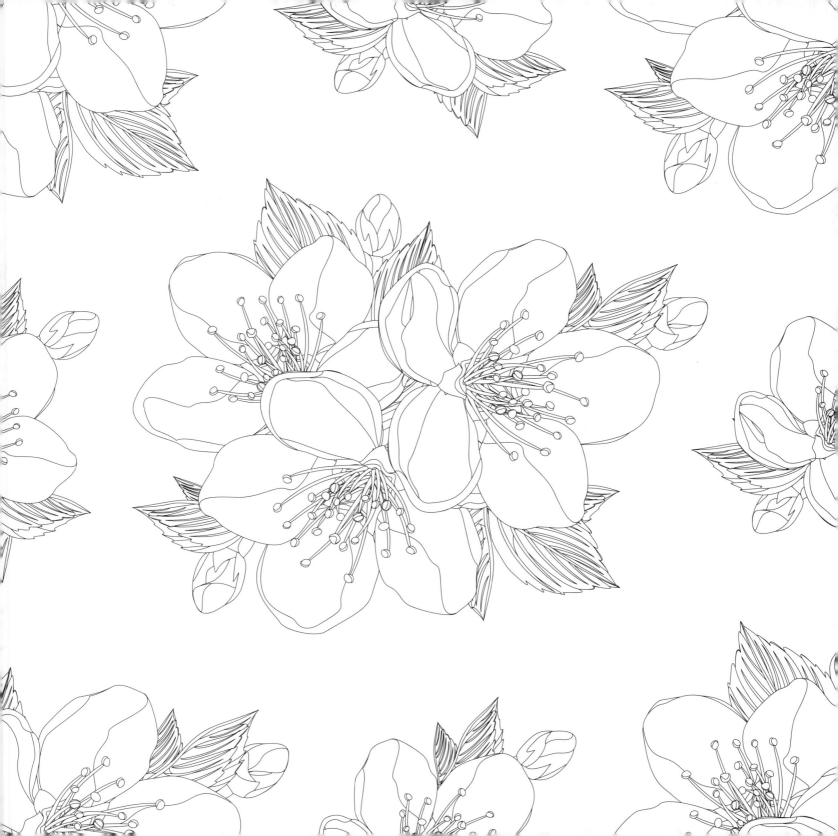

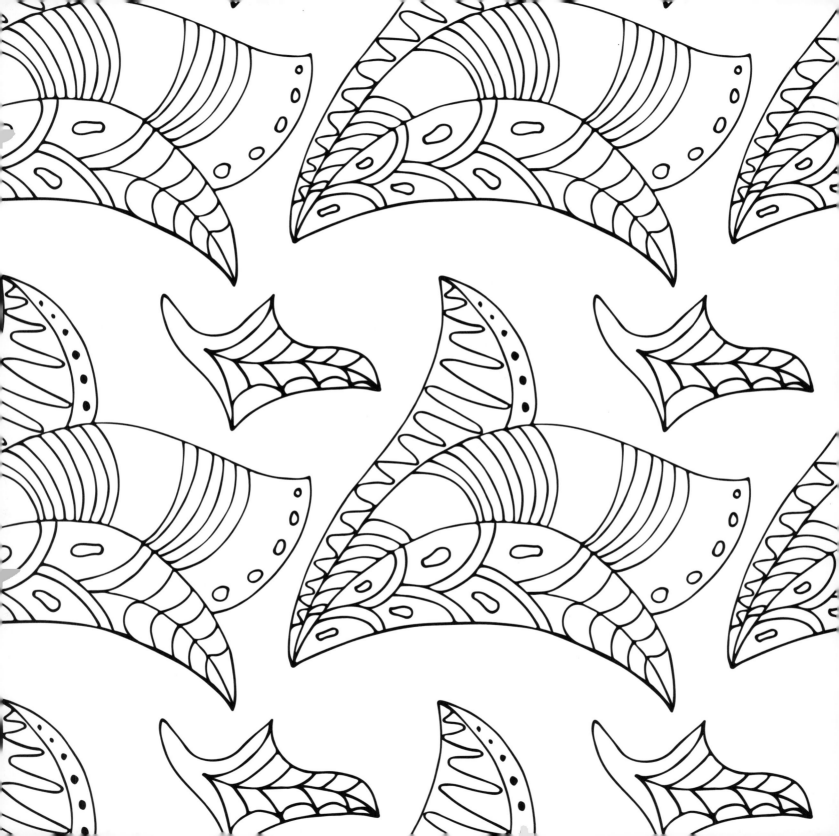

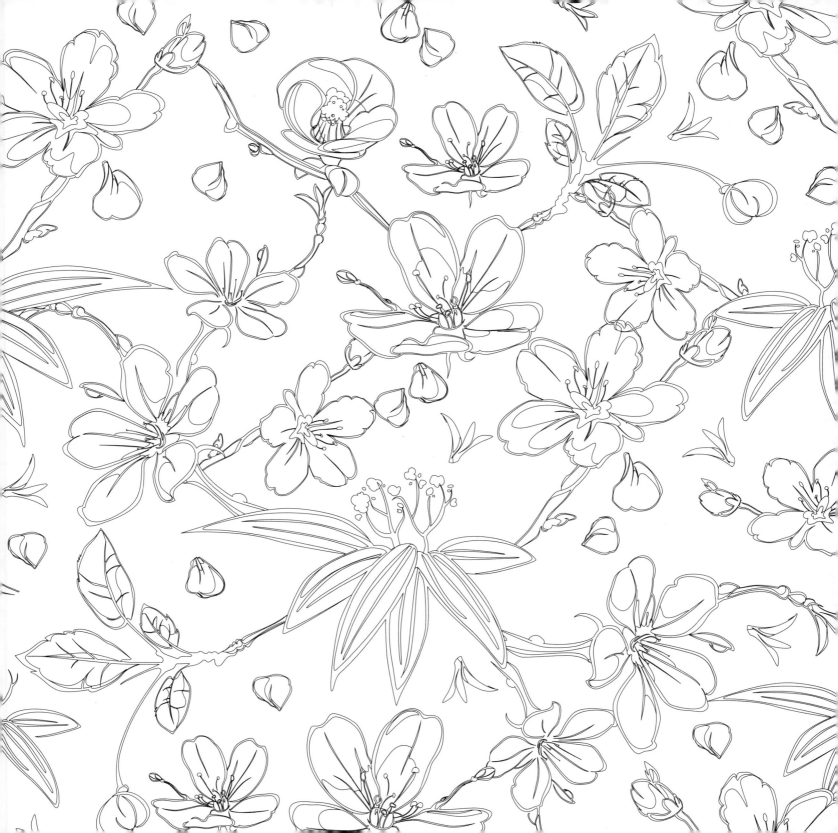

Our mind is the canvas on which the artists lay their color; their pigments are our emotions; their chiaroscuro the light of joy, the shadow of sadness. The masterpiece is of ourselves, as we are of the masterpiece.

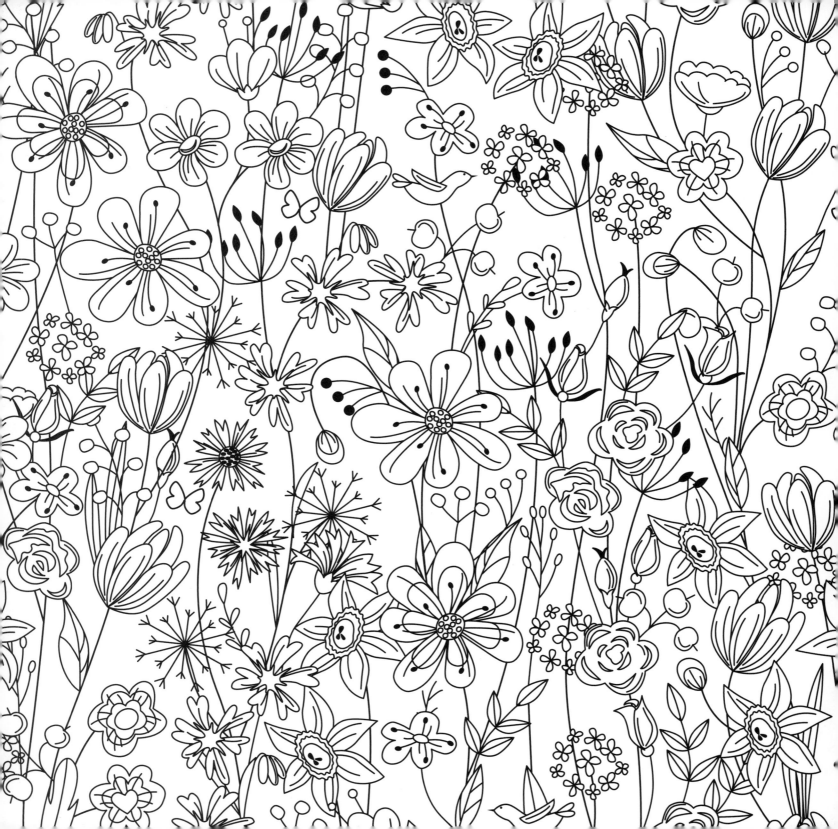

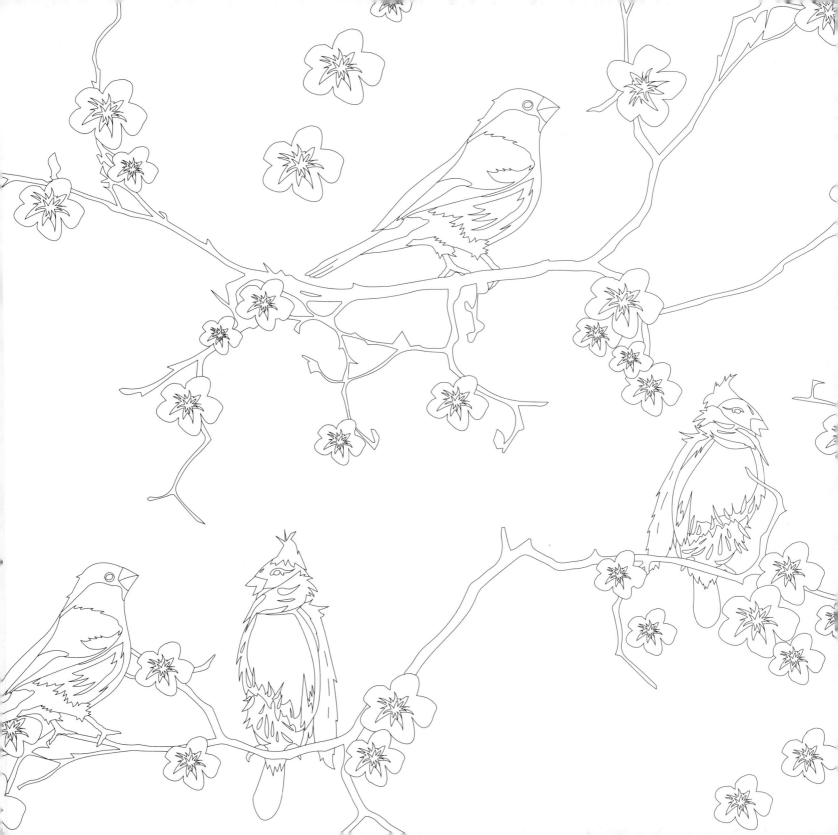

In joy or sadness, flowers
are our constant friends.

Meanwhile, let us have a sip of tea.
The afternoon glow is brightening the bamboos,
the fountains are bubbling with delight,
the soughing of the pines is heard in our kettle.

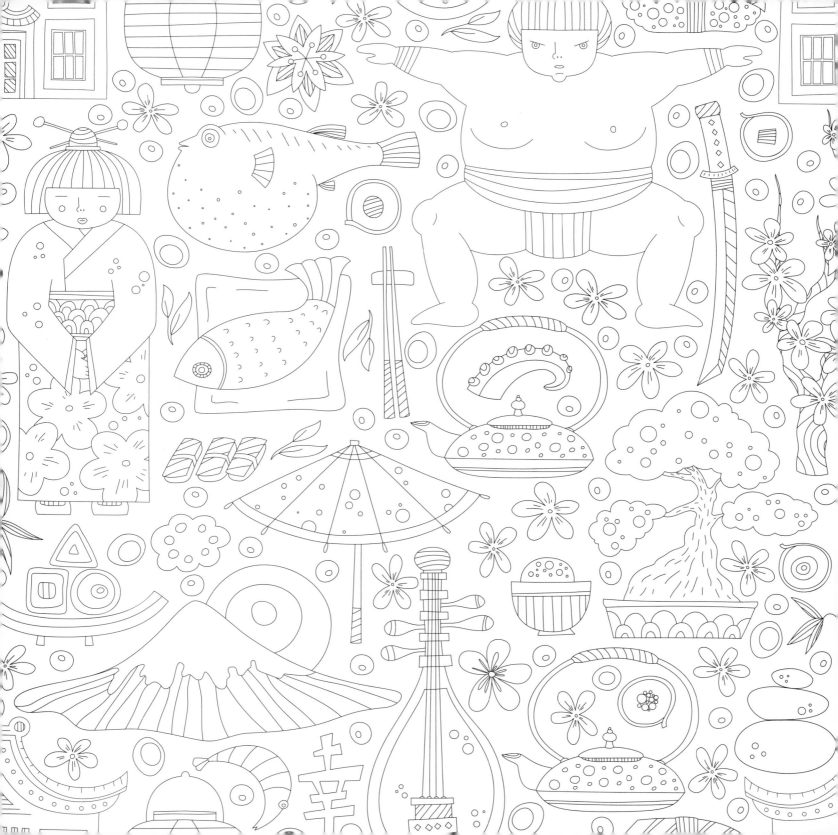

...When we consider how small after all the cup of human enjoyment is... we shall not blame ourselves for making so much of the tea-cup.

Teaism is the art of concealing beauty that you may discover it, of suggesting what you dare not reveal. It is the noble secret of laughing at yourself, calmly yet thoroughly....

The Drawings

The drawings in this book are based on the following prints and designs. Japanese art is sourced from Wikimedia Commons (https://commons.wikimedia.org) unless otherwise noted.

2. Isen'in Hoin Eishin (1775–1828), "Peach Blossom and Dove" (Walters Art Museum)

3. Japanese Geisha © Leshabu (Dreamstime)

4–5. Toyohara (Yōshū) Chikanobu (1838–1912), detail from "The Tea Ceremony"

6. Utagawa Hiroshige (1797–1858), "Teahouse with a View of Mt. Fuji." No. 9 in the series *Thirty-six Views of Mt. Fuji*

7. Hanabusa Itchō (1652–1724) [attributed], "Otafuku" (Los Angeles County Museum of Art)

8. Imao Keinen (1845–1924), "Bird Bathing by Pink Flowers"

9. Toyohara (Yōshū) Chikanobu (1838–1912), "Blowing Wind" (Los Angeles County Museum of Art)

10. Kitagawa Utamaro (1763–1806), "Still Life: Flowers"

11. Kamisaka Sekka (1866–1942), from *Chigusa* (A Thousand Grasses) (Los Angeles County Museum of Art)

12. Anonymous, "Flower Arrangement Upright Style," 1698 (Los Angeles County Museum of Art)

13. Toyohara (Yōshū) Chikanobu (1838–1912), detail from "Group of Women Arranging Flowers"

14. Miyagawa Shuntei (1873–1914), from *Fuzoku ga* (Walters Art Museum)

15. Isen'in Hoin Eishin (1775–1828), "Children Watching a Fan Painter" (Walters Art Museum)

16. Utagawa Toyokuni (1777–1835), "Young Woman in a Boat"

17. Utamaro (1753–1806), detail from "Teahouse Girls Under a Trellised Wisteria"

18. Suzuki Harunobi (1724–1770), "Kite Flying"

19. Mizuno Toshikata (Japan, 1866–1908), "Am'ei Era Woman Composing Poems" from the series *Thirty-six Ways of Loving*

20. Kamisaka Sekka (1866–1942), from *Chigusa* (A Thousand Grasses) (Los Angeles County Museum of Art)

21. Utagawa Kunisada (Toyokuni III) (1786–1865), "Fashionable Man Viewing the Snow" (Los Angeles County Museum of Art)

22. Utagawa Kunisada (Toyokuni III) (1786–1865), "Poem by Kumakada Udaijin" from the series *A Pictorial Commentary on One Hundred Poems By One Hundred Poets* (Los Angeles County Museum of Art)

23. Yoshizawa Setsuan (1809–1889), Leaf from an *Album Depicting Birds, Flowers, Landscapes, and Flower Pots* (Walters Art Museum)

24. Kamisaka Sekka (1866–1942) from *Chigusa* (A Thousand Grasses) (Los Angeles County Museum of Art)

25. Ogata Gekkō (1859–1920), "Nihon hana zue" (Walters Art Museum)

26. Yoshizawa Setsuan (1809–1889), Leaf from an *Album Depicting Birds, Flowers, Landscapes, and Flower Pots* (Walters Art Museum)

27. Matsumura Keibun (1779–1843), "Bird Flying in Autumn Branches"

28. Keisai Eisen (Japan, 1790–1848), "Still Life with Bonsai, Suiseki, and 'Stroking Ox'" (Los Angeles County Museum of Art)

29. Suzuki Harunobu (1724–1770), "Young Woman Bathing in the Summer Rain"

30. Suzuki Harunobu (1724–1770), "Woman Visiting a Shrine By Night"

31. Suzuki Harunobu (1724–1770), "Lady on a Fish Reading "

32–33. Mizuno Toshikata (1866–1908), detail from "The Tea Ceremony"

34. Masanobu (1676–1764), "Three Geisha Enjoying a Snack" (Walters Art Museum)

35. Utamaro (1753–1806), "Portrait of Naniwaya Okita," 1793

36. Lotus Pattern © Michelisola (Dreamstime)

37. Japanese Cloud or Water © Foreks (Dreamstime)

38. Cherry Blossoms © Naddiya (Dreamstime)

39. Blooming Wisteria with Leaves © Sinaappel (Dreamstime)

40. Koi Pattern © Yodke67 (Dreamstime)

41. Butterfly Pattern © Terriana (Dreamstime)

42–43. Bamboo Tree © Snapgalleria (Dreamstime)

44. Japanese Pattern © Lalan33 (Dreamstime)

45. Marigold Flowers © Celticlit (Dreamstime)

46. Set of Teacups © Ekaterina Panova (Dreamstime)

47. Pattern of Waves and Fish © Annykos (Dreamstime)

48. Dragonfly Pattern © Julie_boro (Dreamstime)

49. Chrysanthemums © Reinekke (Dreamstime)

50. Flowers with Japanese Flourish © Terriana (Dreamstime)

51. Teacups and Pots © Juliia Snegireva (Dreamstime)

52. Kimono Background With Crane and Flowers © Macrovector (Dreamstime)

53. Japanese Pattern © Epifantsev (Dreamstime)

54. Peony Pattern © Andrey Kotko (Dreamstime)

55. Pattern of Peonies © Azuzl (Dreamstime)

56. Floral Cup © Alena Akanovich (Dreamstime)

57. Ryūryūkyo Shinsai (1760–1823) [attributed], "Pomegranate Flower" (Los Angeles County Museum of Art)

58. Art Deco Pattern With Overlapping Arcs © supermimicry (Dreamstime)

59. Water Lily © Polina Pomortseva (Dreamstime)

60. Seamless Floral Pattern in a Japanese Style © Teiteosia (Dreamstime)

61. Pattern of Herbs and Flowers © Ekaterina Arkhangelskaia (Dreamstime)

62–63. Wild Field Flowers and Grass © Popmarleo (Dreamstime)

64. Lotus Flower © Betelgejze (Dreamstime)

65. Sakura Blossoms © Silvionka (Dreamstime)

66. Zentangle Pattern © Abdraschitovasvet (Dreamstime)

67. Japanese Flowers © Oksana Pasishnychenko (Dreamstime)

68. Pattern With Japanese Fan © Alexander Kovalenko (Dreamstime)

69. Matcha Tea © Carpierable (Dreamstime)

70. Pattern of Varied Japanese Fans © Verzhh (Dreamstime)

71. Chrysanthemums © Popmarleo (Dreamstime)

72. Floral Pattern With Peonies © Lesia Heno (Dreamstime)

73. Pattern of Ginko Leaves © Lorasutyagina (Dreamstime)

74. Ornamental Pattern of Birds and Flowers in a Japanese Style © Alexey Kuznetsov (Dreamstime)

75. Ornate Poppy Flowers © 1enchik (Dreamstime)

76. Pattern of Stylized Flowers © Annatv81 (Dreamstime)

77. Bullfinches on a Sakura Branch © Lavendertime (Dreamstime)

78. Pattern of Chinese Mums © daniana (Shutterstock)

79. Pattern with Shells © Abdraschitovasvet (Dreamstime)

80. Officinal Brier Fruits and Flowers © Tuja (Dreamstime)

81. Traditional Asian Teapots and Cups © Dina Melnikova (Shutterstock)

82. Abstract Background of Flowers © Aleksandr Evseev (Dreamstime)

83. Two Cups of Tea © Olena Kalashnyk (Dreamstime)

84. Design of China Tea Pots © Lian2011 (Dreamstime)

85. Petals Pattern © Olga Tarakanova (Dreamstime)

86. Tea, Coffee and Sweets Doodle Pattern © Juliia Snegireva (Dreamstime)

87. Birds and Cup of Tea © Popmarleo (Dreamstime)

88. Pattern of Hand-drawn Japanese Symbols © Olga Zakharova (Dreamstime)

89. Cup of Raspberry Tea © Olga Tarakanova (Dreamstime)

90. Tea Cup Pattern © Aiymdesign (Dreamstime)

91. Cartoons on the Subject of Teatime © Olga Kostenko (Dreamstime)

92. Cups of Tea and Pots © Depiano (Dreamstime)

93. Floral Pattern © Marina Vorontsova (Dreamstime)

94. Teapots © Theo Malings (Dreamstime)

Published by Tuttle Publishing, an imprint of
Periplus Editions (HK) Ltd

www.tuttlepublishing.com

ISBN: 978-0-8048-4719-3

Distributed by
North America, Latin America & Europe
Tuttle Publishing
364 Innovation Drive
North Clarendon
VT 05759-9436 U.S.A.
Tel: 1 (802) 773-8930
Fax: 1 (802) 773-6993
info@tuttlepublishing.com
www.tuttlepublishing.com

Asia Pacific
Berkeley Books Pte. Ltd.
61 Tai Seng Avenue #02-12
Singapore 534167
Tel: (65) 6280-1330
Fax: (65) 6280-6290
inquiries@periplus.com.sg
www.periplus.com

19 18 17 16 6 5 4 3 2 1

Printed in China 1606 RR

ABOUT TUTTLE:
"Books to Span the East and West"

Our core mission at Tuttle Publishing is to create books which bring people together one page at a time. Tuttle was founded in 1832 in the small New England town of Rutland, Vermont (USA). Our fundamental values remain as strong today as they were then—to publish best-in-class books informing the English-speaking world about the countries and peoples of Asia. The world has become a smaller place today and Asia's economic, cultural and political influence has expanded, yet the need for meaningful dialogue and information about this diverse region has never been greater. Since 1948, Tuttle has been a leader in publishing books on the cultures, arts, cuisines, languages and literatures of Asia. Our authors and photographers have won numerous awards and Tuttle has published thousands of books on subjects ranging from martial arts to paper crafts. We welcome you to explore the wealth of information available on Asia at **www.tuttlepublishing.com**.